MAKERSPACE TRIOS

Creating with
FELT,
CRAFT STICKS &
CLOTHESPINS

Rebecca Felix

Consulting Editor, Diane Craig,
M.A./Reading Specialist

Super Sandcastle

An Imprint of Abdo Publishing
abdobooks.com

abdobooks.com

Published by Abdo Publishing, a division of ABDO, PO Box 398166, Minneapolis, Minnesota 55439. Copyright © 2022 by Abdo Consulting Group, Inc. International copyrights reserved in all countries. No part of this book may be reproduced in any form without written permission from the publisher. Super SandCastle™ is a trademark and logo of Abdo Publishing.

Printed in the United States of America, North Mankato, Minnesota
102021
012022

THIS BOOK CONTAINS RECYCLED MATERIALS

Design: Sarah DeYoung, Mighty Media, Inc.
Production: Mighty Media, Inc.
Editor: Megan Borgert-Spaniol
Cover Photographs: Mighty Media, Inc.; Shutterstock Images
Interior Photographs: iStockphoto; Kris Kerzman/Flickr; Mighty Media, Inc.; Patrick Barry/Flickr; scottmontreal/Flickr; Shutterstock Images

The following manufacturers/names appearing in this book are trademarks: Elmer's®

Library of Congress Control Number: 2021943246

Publisher's Cataloging-in-Publication Data

Names: Felix, Rebecca, author.
Title: Creating with felt, craft sticks & clothespins / by Rebecca Felix
Description: Minneapolis, Minnesota : Abdo Publishing, 2022 | Series: Makerspace trios |
 Includes online resources and index.
Identifiers: ISBN 9781532196430 (lib. bdg.) | ISBN 9781098218249 (ebook)
Subjects: LCSH: Handicraft--Juvenile literature. | Creative thinking--Juvenile literature. |
 Craft sticks in art--Juvenile literature. | Clothespins--Juvenile literature. |
 Mixed media crafts--Juvenile literature.
Classification: DDC 745.5--dc23

Super SandCastle™ books are created by a team of professional educators, reading specialists, and content developers around five essential components—phonemic awareness, phonics, vocabulary, text comprehension, and fluency—to assist young readers as they develop reading skills and strategies and increase their general knowledge. All books are written, reviewed, and leveled for guided reading and early reading intervention programs for use in shared, guided, and independent reading and writing activities to support a balanced approach to literacy instruction.

TO ADULT HELPERS

The projects in this book are fun and simple. There are just a few things to remember to keep kids safe. Some projects may use sharp or hot objects. Also, kids may be using messy supplies. Make sure they protect their clothes and work surfaces. Be ready to offer guidance during brainstorming and assist when necessary.

CONTENTS

Become a Maker 4

Explore Felt 6

Explore Craft Sticks 8

Explore Clothespins 10

Get Inspired 12

Maker Tools 14

Making Your Makerspace 16

Display It 18

Wear It 20

Use It 22

Build It 24

Gift It 26

Play with It 28

Keep On Making 30

Glossary 32

BECOME A MAKER

A makerspace is like a laboratory. It's a place where ideas are formed and problems are solved. Kids like you create amazing things in makerspaces. Many makerspaces are in schools and libraries. But they can also be in kitchens, bedrooms, and backyards. Anywhere can be a makerspace when you use imagination, inspiration, collaboration, and problem-solving!

Imagination

This takes you to new places and lets you experience new things. Anything is possible with imagination!

Inspiration

This is the spark that gives you an idea. Inspiration can come from almost anywhere!

Makerspace Toolbox

Collaboration

Makers work together. They ask questions and get ideas from everyone around them. Collaboration solves problems that seem impossible.

Problem-Solving

Things often don't go as planned when you're creating. But that's part of the fun! Find creative solutions to any problem that comes up. These will make your project even better.

EXPLORE FELT

Felt is a thick fabric used in many ways. It is sometimes placed in instruments to soften sound. It is also used as padding for moving parts in machinery. People also craft with felt to make puppets, pet toys, clothing, and more!

Felt Properties

▶ **Flexible**

▶ Fuzzy

▶ Soft

▶ Springy

How Can You Use Felt?

Felt has many standard uses. But it can be used however you like in a makerspace! Let your imagination wander. What would it look like to use felt in a new way?

Felt as Decoration
Could you make hair or braids out of it?

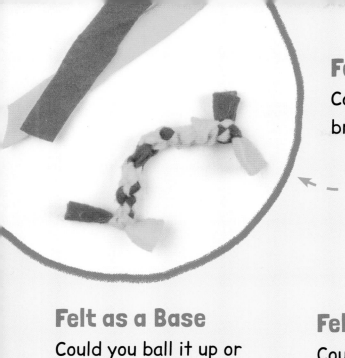

Felt Converted
Could you pull it apart into fuzz?

Felt as a Base
Could you ball it up or use it as stuffing to create structure?

Felt as a Tool
Could you use it to make a stamp?

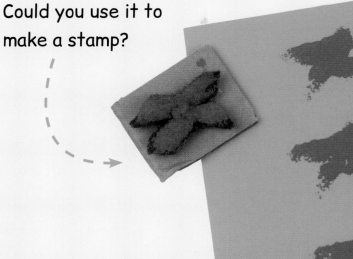

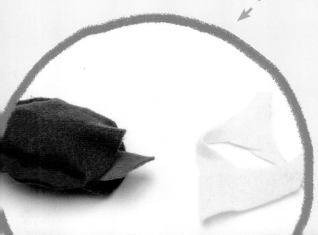

EXPLORE
CRAFT STICKS

Craft sticks are flat wooden sticks that come in different sizes. You might know them best as the sticks in popsicles! People also use craft sticks to build bird houses, catapults, and all kinds of other projects.

Craft Stick Properties

▶ Flat
▶ Smooth
▶ Sturdy
▶ Wooden

How Can You Use Craft Sticks?

Craft sticks have many common uses. But they can be used however you like in a makerspace! Let your imagination wander. What would it look like to use craft sticks in a new way?

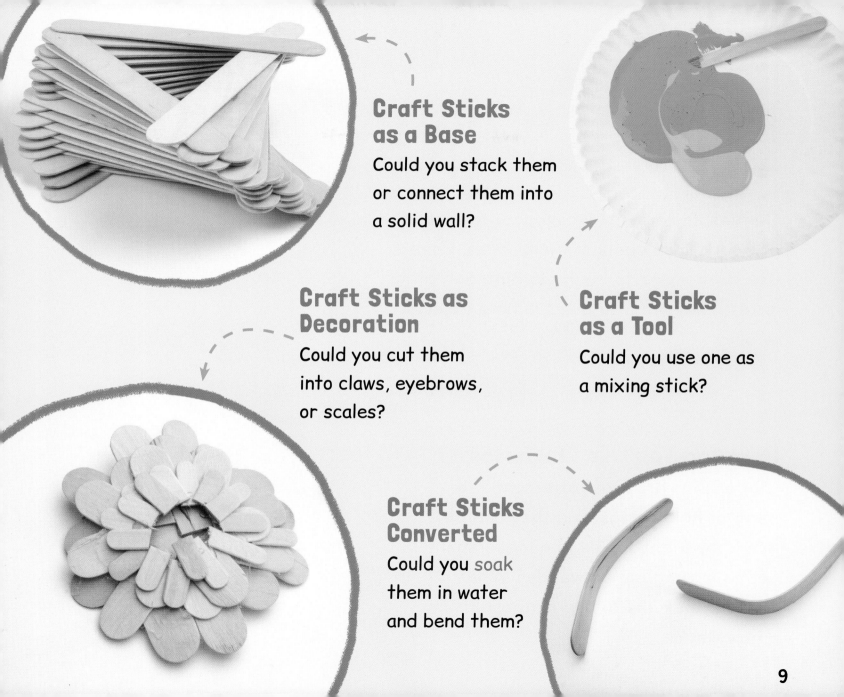

Craft Sticks as a Base

Could you stack them or connect them into a solid wall?

Craft Sticks as Decoration

Could you cut them into claws, eyebrows, or scales?

Craft Sticks as a Tool

Could you use one as a mixing stick?

Craft Sticks Converted

Could you soak them in water and bend them?

9

EXPLORE
CLOTHESPINS

Clothespins are small **clamps** often made of wood. They come in many sizes. People use clothespins to hang clothing and other items. They are also used to hold objects in place.

Clothespin Properties

► Spring-loaded
► Strong grip
► Two-**pronged**
► Wooden

How Can You Use Clothespins?

Clothespins are most often used to hang or hold things. But they can be used however you like in a makerspace! Let your imagination wander. What would it look like to use clothespins in a new way?

Clothespins as Decoration

Could you use them as legs, spikes, or hair?

Clothespins as a Base

Could you clip several together into a structure?

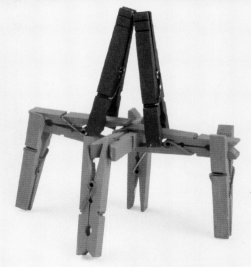

Clothespins as a Tool

Could they hold materials in place while glue dries?

Clothespins Converted

Could you take them apart and use the springs and prongs separately?

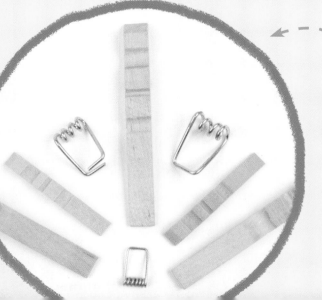

GET INSPIRED

People have used felt, craft sticks, and clothespins in all kinds of creative ways. Let these examples spark your imagination!

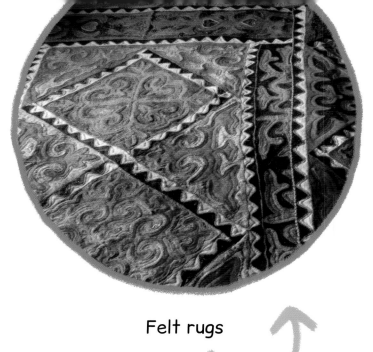

Felt rugs

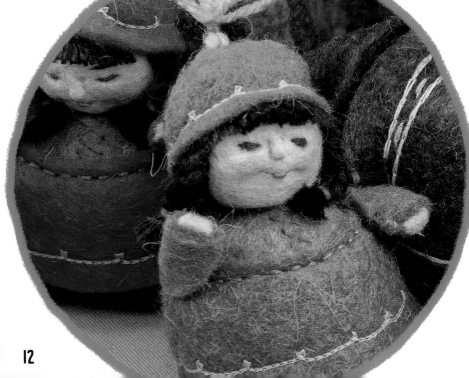

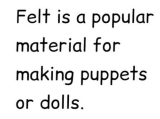

Felt is a popular material for making puppets or dolls.

College students in North Dakota engineered these craft stick sculptures.

Clothespin art

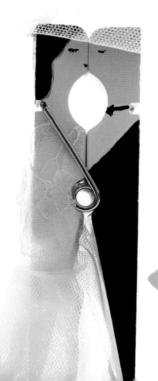

What images come to mind when you look at a clothespin?

This model of the International Space Station is made of craft sticks!

MAKER TOOLS

Are you inspired? Have you brainstormed some makerspace projects? It's time to gather your felt, craft sticks, and clothespins. You may also need a few everyday tools to cut and connect your primary materials.

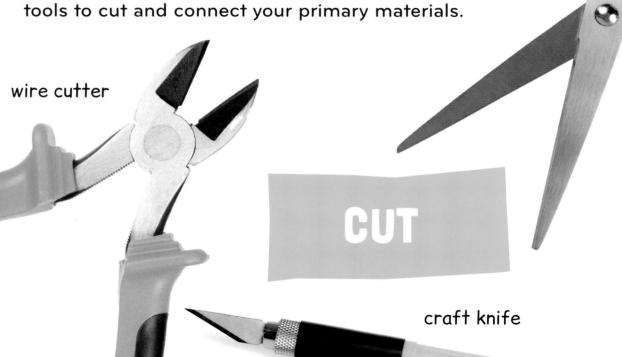

wire cutter

scissors

CUT

craft knife

glue stick

CONNECT

craft glue

hot glue

A LITTLE EXTRA

You may be able to bring your ideas to life with only felt, craft sticks, and clothespins. But you can always add more details if you have extra materials to work with. These could be paint, buttons, pom-poms, or whatever else you have on hand!

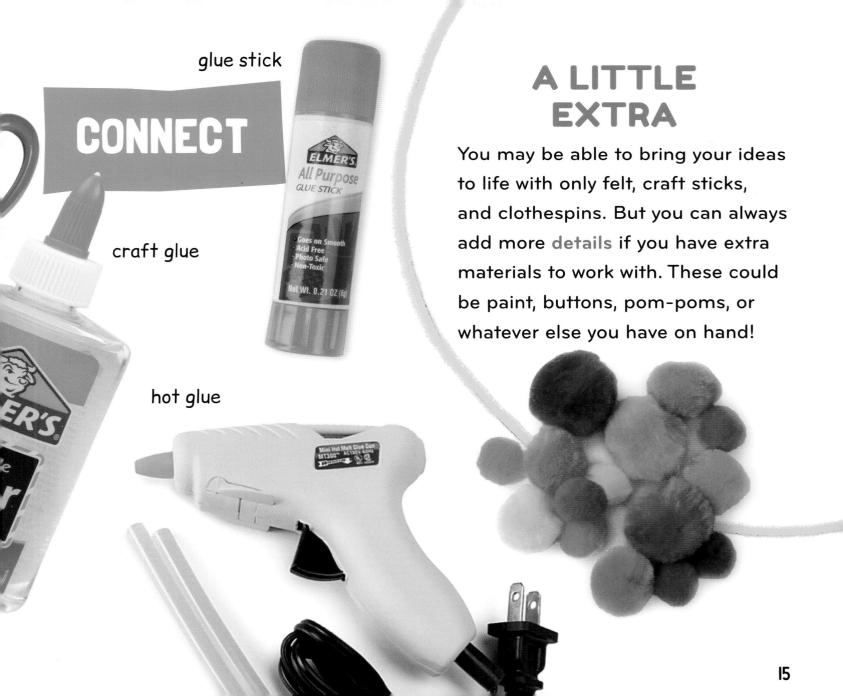

15

MAKING YOUR MAKERSPACE

You can let your imagination run wild in a makerspace. But be sure to follow these rules to stay safe and be respectful.

1 Gather your materials

Make sure an adult says it's OK to use what you gather.

2 Be safe

Ask an adult for help when using sharp or hot tools, such as craft knives or glue guns.

3 Share the space

Share supplies and space with other makers. You can invite them to share their ideas if you're feeling stuck!

4 Keep trying

Don't give up when things don't go exactly as planned. Instead, think about the problem you are having. What are some ways to solve it?

5 Clean up

Put away materials. Find a safe space to store unfinished projects until next time. And clean up any scraps, spills, or messes you made.

DISPLAY IT

Create an artwork from felt, craft sticks, and clothespins. Then put it on display!

Cut up leftover felt scraps to add a pop of color to artworks.

Craft sticks make a solid base. Make hangers out of felt strips and clothespins.

Glue the ends of felt strips to the handles of clothespins. The clothespin can hold more items, creating a mobile.

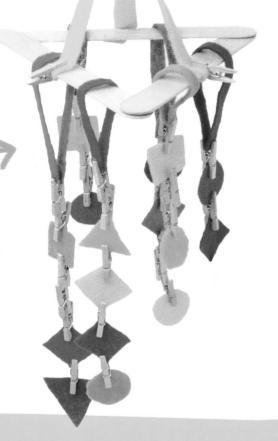

Imagine

Imagine ideas without size limits. What if your artwork were as big as a car? As small as a button?

You can easily add to the mobile, break it apart, or swap items around!

Your Turn!

What could you create from felt pieces that are rolled or balled up?

What could you do with craft sticks that have been cut into small pieces?

How would you use clothespins to make a frame for your artwork?

WEAR IT

What wearable clothing or accessories could you make from felt, craft sticks, and clothespins?

Paint craft stick pieces to look like buttons or buckles.

Felt can be cut and glued together to create suspenders.

Clothespins can act as suspender clips!

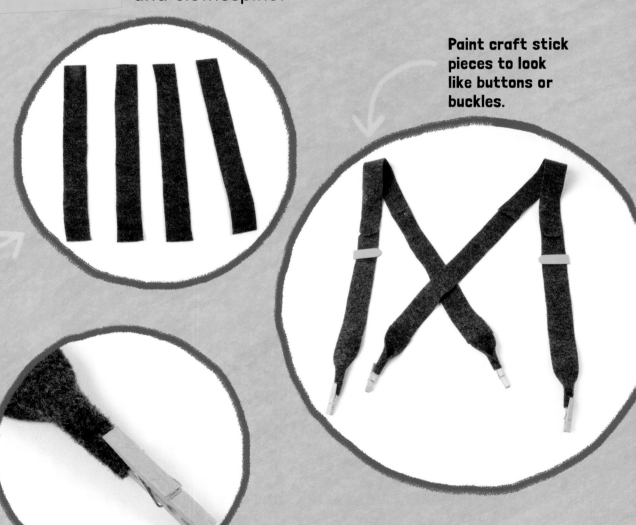

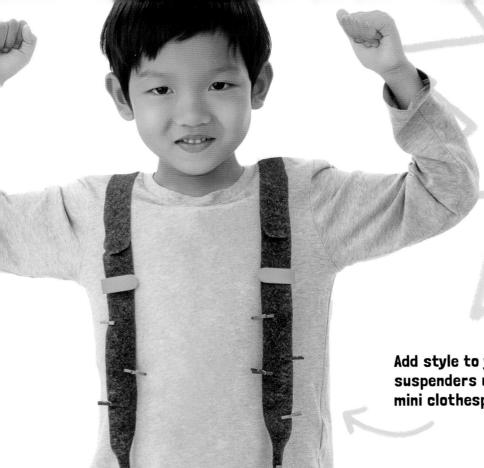

Problem-Solve

Every problem has a solution. Do your suspenders keep slipping off your shoulders? Fold them at the bottoms to make them tighter. Then secure the folds with a clothespin.

Add style to your suspenders using mini clothespins.

Your Turn!

Could you use felt to make mittens or a hat?

Could craft sticks be made into a watch or bracelet?

How might you turn clothespins into hair clips or earrings?

USE IT

Think of an item you need. Then design it! Felt, craft sticks, and clothespins provide many options for functional projects.

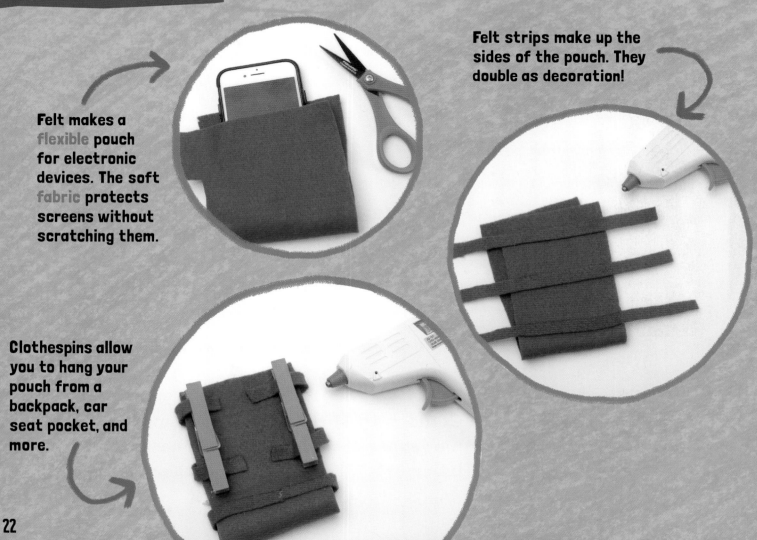

Felt makes a flexible pouch for electronic devices. The soft fabric protects screens without scratching them.

Felt strips make up the sides of the pouch. They double as decoration!

Clothespins allow you to hang your pouch from a backpack, car seat pocket, and more.

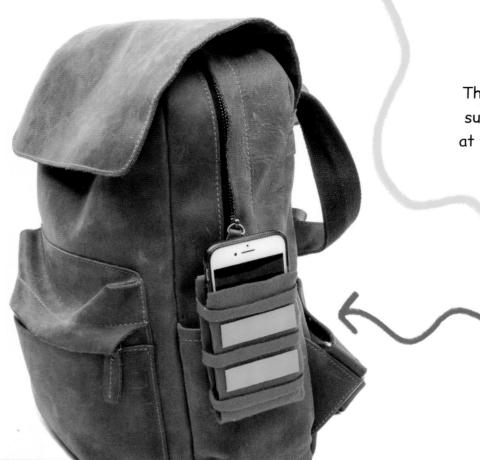

Get Inspired

Think about items you use every day, such as folders or lunch boxes. Look at these functional items as you come up with your own designs.

Painted craft sticks provide color and extra support.

Your Turn!

Could you turn felt into a backpack? What about a case for sunglasses?

How might you turn craft sticks into a place mat?

How could clothespins be used to make handles or straps?

BUILD IT

Engineers use all kinds of materials to build. What do you want to construct? Can you do it using only felt, craft sticks, and clothespins?

Felt can become **shingles**, flowers, or other **details**. It can also be used as stuffing to give objects volume or padding.

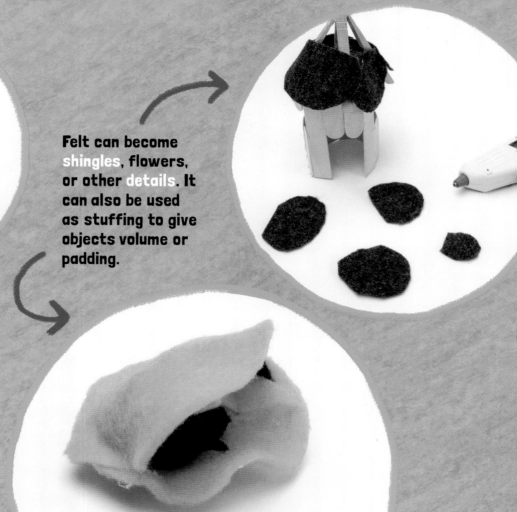

Craft sticks and clothespins create a solid structure. Craft sticks can be cut to size. Clothespins can be taken apart.

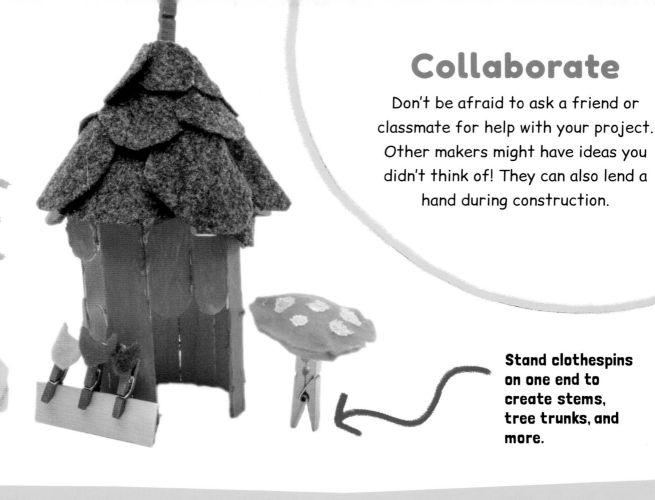

Collaborate

Don't be afraid to ask a friend or classmate for help with your project. Other makers might have ideas you didn't think of! They can also lend a hand during construction.

Stand clothespins on one end to create stems, tree trunks, and more.

Your Turn!

Could felt be tightly rolled into a solid structure?

How would you engineer a bridge or tower out of craft sticks?

Could clothespins alone create the base of a structure?

GIFT IT

Is a holiday or birthday coming up? Do you want to surprise a friend or family member just for fun? You can make all kinds of homemade gifts using felt, craft sticks, and clothespins.

Soak craft sticks in water for a few hours. Then carefully bend them inside a bowl. Once dry, the craft sticks will keep the curved shape!

Use curved craft sticks to make animal shells, bridges, and other rounded objects.

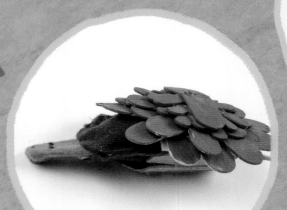

Make a felt body that can fit inside the shell.

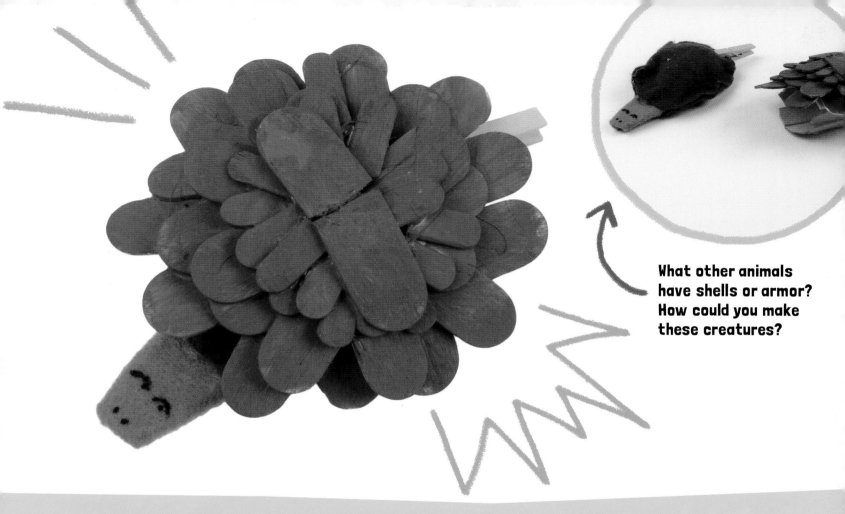

What other animals have shells or armor? How could you make these creatures?

Your Turn!

Could you make a felt sleeve for warm and cold drinks?

Could craft sticks be soaked and bent to create a globe?

How could you display photos using clothespins?

PLAY WITH IT

Looking for something fun to do? Use felt, craft sticks, and clothespins to create your own toys and games!

Peg clothespins make great puppet bases! They could be part of the puppet, such as an insect body. Or they could be the piece the puppeteer holds out of sight.

Break spring-loaded clothespins apart to make legs, wings, and more.

Glue felt pieces together to make faces, wings, stripes, or other fun details.

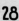

Clothespin springs can be decoration too!

Your Turn!

Could felt be rolled into a baseball? Could it cover a game board?

Could craft sticks be used as game pieces or in a stacking game?

How would you turn clothespins into bowling pins?

KEEP ON MAKING

Your felt, craft stick, and clothespin projects may look complete, but don't close your makerspace toolbox yet. Think about what would make these projects even better. What would you do differently if you made each one again? What would happen if you used different methods or added another material?

Beyond the Makerspace

You can use your makerspace toolbox beyond the makerspace! You might use it to accomplish everyday tasks, such as hanging up your coat or storing your art supplies. But makers use the same toolbox to do big things. One day, these tools could be used to create a famous artwork or new type of communication device. Turn your world into a makerspace! What problems could you solve?

GLOSSARY

accessory – a piece of jewelry or clothing that makes an outfit appear more complete.

catapult – a machine used to throw things.

clamp – something that holds or presses things together.

collaboration – the act of working with others.

design – to plan how something will appear or work. A design is a sketch or outline of something that will be made.

detail – a small part of something.

fabric – woven material or cloth.

flexible – easy to move or bend.

mobile – an artistic device with parts that are arranged so they will move in the air currents.

prong – one of the sharp points of a fork, tool, or antler.

shingle – one of the thin tiles that go on the roof or sides of a building.

soak – to leave something in a liquid for a while.

solution – an answer to, or a way to solve, a problem.

suspenders – straps worn over the shoulders that help hold up pants or a skirt.